RENDERING IN PEN AND INK

INSTRUCTION PAPER

PREPARED BY

DAVID A. GREGG,

TEACHER AND LECTURER IN PEN AND INK RENDERING
MASSACHUSETTS INSTITUTE OF TECHNOLOGY

Copyright © 2013 Read Books Ltd.
This book is copyright and may not be
reproduced or copied in any way without
the express permission of the publisher in writing

British Library Cataloguing-in-Publication Data
A catalogue record for this book is available from the
British Library

Drawing and Illustration

Drawing is a form of visual art that can make use of any number of drawing instruments, including graphite pencils, pen and ink, inked brushes, wax colour pencils, crayons, charcoal, chalk, pastels and various kinds of erasers, markers, styluses, metals (such as silverpoint) and even electronic drawing. As a medium, it has been one of the most popular and fundamental means of public expression throughout human history – as one of the simplest and most efficient means of communicating visual ideas.

Drawing itself long predates other forms of human communication, with evidence for its existence preceding that of the written word – demonstrated in cave paintings of around 40,000 years ago. These drawings, known as pictograms, depicted objects and abstract concepts including animals, human hands and generalised patterns. Over time, these sketches and paintings were stylised and simplified, leading to the development of the written language as we know it today. This form of drawing can truly be considered art in its purest sense – the basic forms on which all others build.

Whilst the term 'to draw' derives from the Old English *dragan* (meaning 'to drag, draw or protract'), the word 'illustrate' derives from the Latin word *illustratio,* meaning 'enlighten' or 'irradiate'. This process of 'enlightenment' is central to drawing and illustration as we know it today. Medieval codices' illustrations were often called 'illuminations', designed to highlight and further explain

important aspects of biblical texts. This was the most general form of illustration; hand-created, individual and unique. This changed in the fifteenth century however, when books began to be illustrated with woodcuts – most notably in Germany, by Albrecht Dürer.

The first creative impulses of a painter or sculptor are commonly expressed in drawings, and architects and photographers are commonly trained to draw, if for no other reason than to train their perceptual skills and develop their creative potential. Initially, artists used and re-used wooden tablets for the production of their drawings, however following the widespread availability of paper in the fourteenth century, the use of drawing in the arts increased. During the Renaissance (a period of massive flourishing of human intellectual endeavours and creativity), drawings exhibiting realistic and representational qualities emerged. Notable draftsmen included Leonardo da Vinci, Michelangelo and Raphael. They were inspired by the concurrent developments in geometry and philosophy, exhibiting a true synthesis of these branches – a combination somewhat lost in the modern day.

Figure drawing became a recognised subsection of artistic drawing in this period, despite its long history stretching back to prehistoric descriptions. An anecdote by the Roman author and philosopher Pliny, describes how Zeuxis (a painter who flourished during the 5th century BCE) reviewed the young women of Agrigentum naked before selecting five whose features he would combine in order to paint an ideal image. The use of nude models in the medieval artist's workshop is further implied in the writings

of Cennino Cennini (an Italian painter), and a manuscript of Villard de Honnecourt confirms that sketching from life was an established practice by the thirteenth century. The Carracci, who opened their *Accademia degli Incamminati* (one of the first art academies in Italy) in Bologna in the 1580s, set the pattern for later art schools by making life drawing the central discipline. The course of training began with the copying of engravings, then proceeded to drawing from plaster casts, after which the students were trained in drawing from the live model.

The main processes for reproduction of drawings and illustrations in the sixteenth and seventeenth centuries were engraving and etching, and by the end of the eighteenth century, lithography (a method of printing originally based on the immiscibility of oil and water) allowed even better illustrations to be reproduced. In the later seventeenth and eighteenth centuries, the previous combination of the arts and sciences in drawing gave way to a more romantic and even classical style, epitomised by draftsmen such as Poussin, Rembrandt, Rubens, Tiepolo and Antoine Watteau. Mastery in drawing was considered a prerequisite to painting, and students in Jacques-Louis David's Studio (a famed eighteenth century French painter of the neo-classical style), were required to draw for six hours a day, from a model who remained in the same pose for an entire week!

During this period, an increasingly large gap started to emerge between 'fine artists' on the one hand, and 'draftsmen' / 'illustrators' on the other. This difference became further complicated with the 'Golden Age of Illustration'; a period customarily defined as lasting from the

latter quarter of the nineteenth century until just after the First World War. In this period of no more than fifty years the popularity, abundance and most importantly the unprecedented upsurge in quality of illustrated works marked an astounding change in the way that publishers, artists and the general public came to view artistic drawing. Arthur Rackham, Walter Crane, John Tenniel and William Blake are some of its most famous names. Until the latter part of the nineteenth century, the work of illustrators was largely proffered anonymously, and in England it was only after Thomas Bewick's pioneering technical advances in wood engraving that it became common to acknowledge the artistic and technical expertise of illustrators. Such draftsmen also frequently used their drawings in preparation for paintings, further obfuscating the distinction between drawing/painting, high/low art.

The artists involved in the Arts and Crafts Movement (with a strong emphasis on stylised drawing, and a powerful influence on the 'Golden Age of Illustration') also attempted to counter the ever intruding Industrial Revolution, by bringing the values of beautiful and inventive craftsmanship back into the sphere of everyday life. This helped to counter the main challenge which emerged around this time – photography. The invention of the first widely available form of photography (with flexible photographic film role marketed in 1885) led to a shift in the use of drawing in the arts. This new technology took over from drawing as a superior method of accurately representing the visual world, and many artists abandoned their painstaking drawing practices. As a result of these developments however, modernism in the arts emerged – encouraging 'imaginative

originality' in drawing and abstract formulations. Drawing was once again at the forefront of the arts.

There are many different categories of drawing, including figure drawing, cartooning, doodling and shading. There are also many drawing methods, such as line drawing, stippling, shading, hatching, crosshatching, creating textures and tracing – and the artist must be aware of complex problems such as form, proportion and perspective (portrayed in either linear methods, or depth through tone and texture). Today, there are also many computer-aided drawing tools, which are utilised in design, architecture, engineering, as well as the fine arts. It is often exploratory, with considerable emphasis on observation, problem-solving and composition, and as such, remains an unceasingly useful tool in the artists repertoire.

The processes of drawing is a fascinating artistic practice, enabling a beautiful array of effects and creative expression. As is evident from this short introduction, it also has an incredibly old history, moving from decorations on cave walls to the most advanced, realistic and imaginative drawings possible in the present day. It is hoped that the current reader enjoys this book on the subject.

RENDERING IN PEN AND INK.

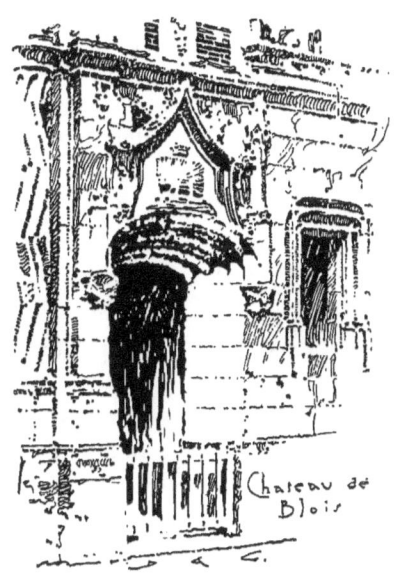
Chateau de Blois

To render in pen and ink a large and important drawing is no small accomplishment. Usually years of experience are necessary before one can sucessfully undertake such drawings. Now and then a student is to be found having talent to the extent that the attainment of this skill seems a very easy matter, but in general this talent is comparatively rare. Ninety-five out of every hundred have a long task ahead before success is possible. This difficulty of attainment, however, makes the accomplishment all the more valuable. No one would expect to learn engraving on wood in a few brief lessons, and yet in pen and ink rendering difficulties are to be met not unlike those connected with engraving.

But there are many things concerning pen and ink work which can be readily learned; they are worth the trouble and the labor expended, and may prove useful. A consideration of these will, in any case, introduce the art and serve also as a good foundation for further pursuit of the subject if desired.

It is the purpose of this paper to seek the most modest of results, which may be set forth thus,—the rendering of a small building at a small scale in the very simplest manner, with few or no accessories.

Kind of Drawing. There are three ways in which a sketch may be rendered, viz: with pen, pencil, or brush. Pen rendering will be considered first, and later additional notes will be made as to pencil work. Rendering with the brush is another line of work,

but much that may be advised in regard to pen rendering would also apply to brush work.

MATERIALS.

Pens. The tendency of beginners is to use too fine a pen. It must be remembered that many pen drawings are reproductions much smaller than the originals, and consequently the lines appear much finer than in the drawing itself. There are two pens that can be recommended, shown herewith. Years of experience prove them to be perfectly satisfactory. Occasionally a finer pen is needed, such as Gillott No. 303. The Esterbrook No. 14, a larger pen, is necessary in making the blacker portions of a drawing. The Gillott 404 is to be used for general work in the same drawing.

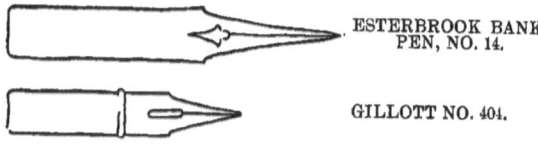

ESTERBROOK BANK PEN, NO. 14.

GILLOTT NO. 404.

Ink is not of as much importance as pens. The various prepared India inks put up in bottles are all that can be desired. They are more convenient than ink that must be rubbed up, and they have the advantage of always being properly black. Some ordinary writing inks serve the purpose very well if reproduction is not an object, but if reproduction is desired, India ink, being black, is preferred.

Paper. The very best surface is a hard Bristol board. The softer kinds of Bristol boards should be avoided, as they will not stand erasure. Most of the drawing papers do very well. Whatman's hot pressed paper is very satisfactory. An excellent drawing surface is obtained by mounting a smooth paper on cardboard, thus obtaining a level surface that will not spring up with each pressure of the pen. This is equivalent to a Bristol board. However, the size of Bristol board is limited and frequently drawings must be much larger, in which case the mounted paper is a necessity.

LINE WORK.

Quality of Line. Too much stress cannot be laid on the importance of a good line, however insignificant it may seem. Care in each individual line is absolutely necessary for good work. A line

RENDERING

GOOD QUALITY OF LINE.

that is stiff and hard, feeble, scratchy or broken, will not do. Such work will ruin a drawing that in other respects may be excellent. The accompanying illustration by one of the students of the Massachusetts Institute of Technology is an example of excellent quality of line. Each line, even to the very smallest, has grace and beauty. By a very few, the ability to make such lines is speedily acquired—but by a few only—others may attain it by careful practice.

Every line of a drawing—the outline of the building and each line of the rendering, even to the very shortest must be done feelingly, gracefully, positively. Usually a slight curve is advisable and if long lines are used, a quaver or tremble adds much to the result. Each line of a shadow should have a slight pressure of the pen at the lower end. This produces a dark edge in the group of lines that

make the shadows, giving definiteness to the shadow and contrast to the white light below it.

Method. The combination of individual lines produces what we may term a method. The individual line may be good but the combining may be unfortunate. In making a wash drawing no thought is necessary concerning the direction of the wash, but in using lines at once the query arises as to what direction they

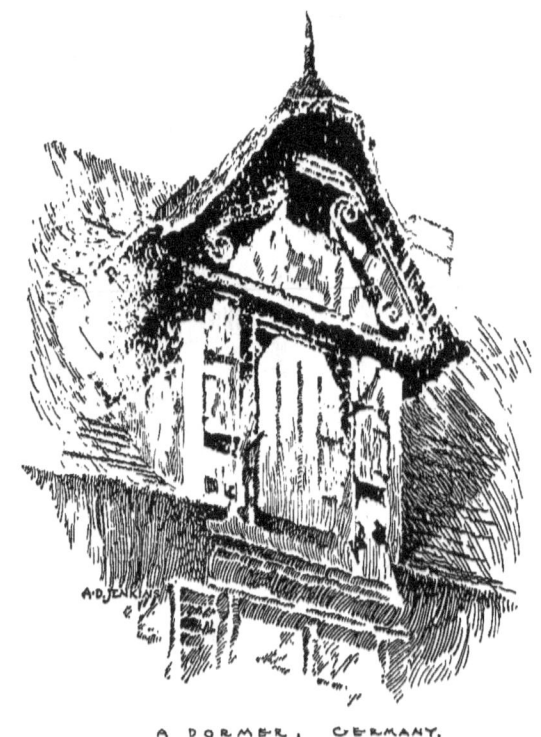

A DORMER, GERMANY.
EXCELLENT METHOD

shall take. A method is something one must grow into from a small, simple beginning. The accompanying illustration, the work of another Massachusetts Institute of Technology student, is an example of rare skill in method quickly acquired. There is an utter absence of anything rigid or mechanical in the whole. Observe how softly the edges of the drawing merge into the white of the paper. The vigor of the drawing is gathered in the dormer itself.

RENDERING

Vertical Lines. The simplest method is obtained by the use of the vertical line. Some drawings can be made entirely by this means. See Fig. 3, every line of which is vertical. This illustrates the value of a good individual line. It will be observed that although vertical, these lines are not severely straight and stiff, they tremble a little, or have a slight suggestion of a curve. In the shad-

Fig. 3.
VERTICAL LINE METHOD.

ow at the bottom of the drawing each line is emphasized at the top by a slight pressure, and made thin at the lower end in order to soften off the edges of the drawing as a whole.

Free Lines. Fig. 4 shows another method. The vertical line is discarded and the freest possible line is used. No one direction is followed, but the lines go in any or all directions. Which

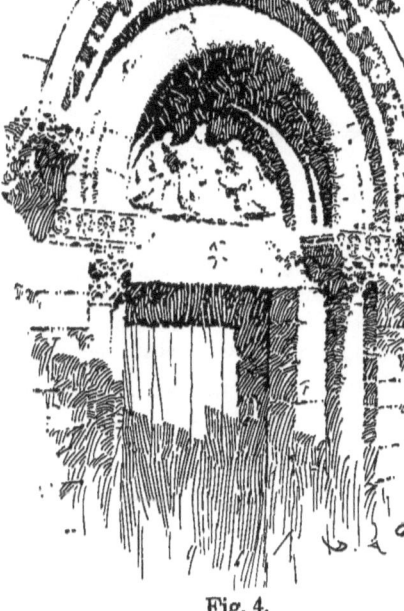

Fig. 4.
FREE LINE METHOD.

is the better method? The answer doubtless must be that the free method is the least conspicuous. It is better adapted for general use, in the showing of various surfaces and textures.

VARIOUS EXAMPLES OF BAD METHODS.

A

Short, broken line, resulting in a spotty effect; a fault common with beginners. The white spaces between the ends of the lines are very conspicuous.

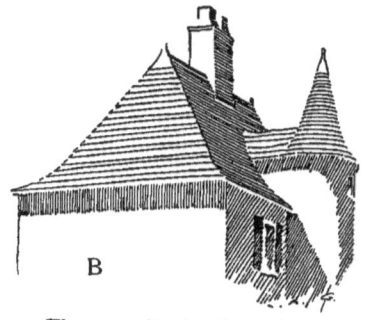

B

The opposite in character to A. Long, unbroken lines, but so severely straight as to be hard and dry in general appearance.

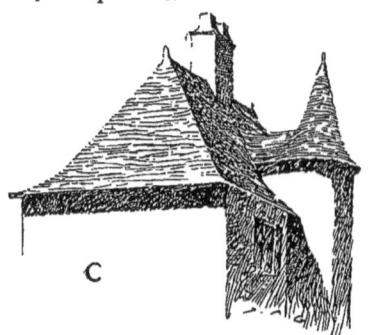

C

Short lines, individually they may be very good, as they curve freely, but the combination is fussy and finnicky.

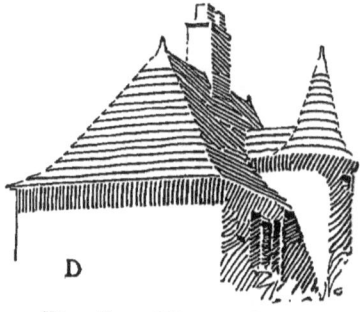

D

Direction of line not bad, but is rather too coarse to be agreeable. Wide spacing of lines on light portions add to the coarse result.

These illustrate four bad methods. A has the least merit, the others approach to a fair quality. In E an effort is made to avoid all the faults shown in the others—the short or severely straight line, the over labor combination of C, and the coarse line of D.

LIGHT AND SHADE.

Values. If several lines are drawn parallel and quite close together, but not touching, a gray, or half-tone value is the result.

Lines drawn so close together that the ink of one runs into that of the other, with little or no white space between, give a black

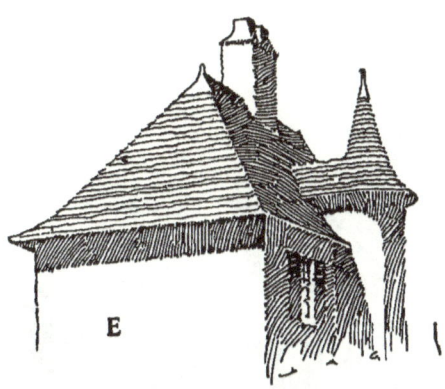

value. The white of the paper untouched by the pen gives a white value. Fig. 5 shows only two values—black and white; Fig. 6 also has two,—gray and white; Fig. 7 has the three,—black, gray and white. The first is harsh, the second is pale, and the third seems most satisfactory.

This is a safe rule to follow —get into every pen drawing, black, gray and white. Usually, in early attempts, there is a tendency to omit the black. Look for the place in the

Fig. 5.
BLACK AND WHITE.

Fig. 6.
GRAY AND WHITE.

Fig. 7.
BLACK, GRAY AND WHITE.

drawing where you can locate this black; you are not likely to get too much of it. Let the half tone or gray be rather light, midway in strength between white and black. A heavy half tone is

Fig. 8.
ONE SIDE IN SHADE.

a dangerous value. The black may often grade off into the gray, or there may be distinct fields or areas of each value.

Lighting. The first thing to consider in the rendering of an architectural subject is the choosing of the direction of light. Sometimes when the building is turned well to the front, showing

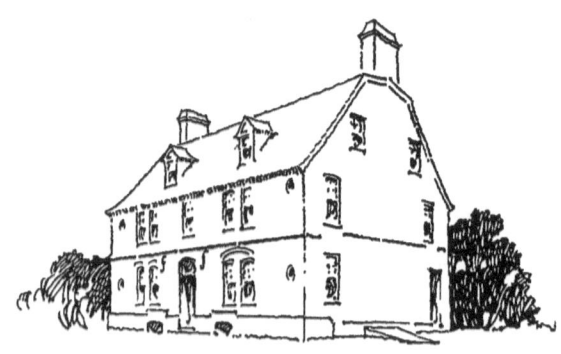

Fig. 9.
ALL IN LIGHT.

a sharp return of the end, it may be best to put that side in shade, Fig. 8, but it is not necessary. Values may be obtained by other means such as by shadows, or color of material. It is not wise to attempt a heavy rendering in pen work. Usually it is safer

to keep both sides of the building in light as shown in two of these sketches, Figs. 9 and 10.

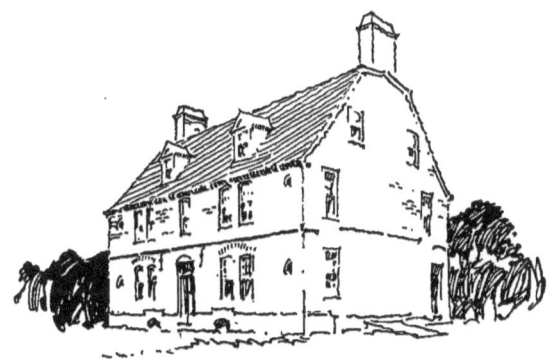

Fig. 10.
ALL IN LIGHT WITH HALF-TONE VALUE TO ROOF.

Color of Material. One of the means by which values may be introduced into a rendering, is by considering the color of the material of which the building is constructed.

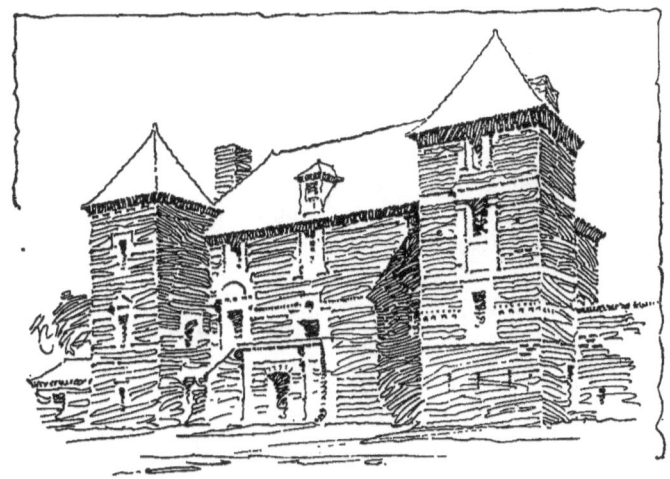

Fig. 11.
HALF-TONE WALLS.

In this example, Fig. 11, we may first use the brick walls as a place to locate a gray value. In the second example, Fig. 12, the roof is used for the same value. For the very dark or black value we must depend on the shadows. Neither one of these draw-

ings is wholly satisfactory. In the first, the roof, and in the other, the walls, seem too glaringly white. For that reason it is not always best to use the material color so broadly. To give color to

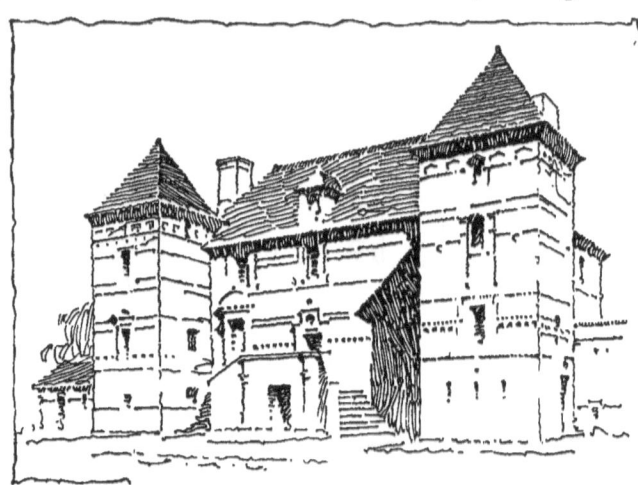

Fig. 12.
HALF-TONE ROOF.

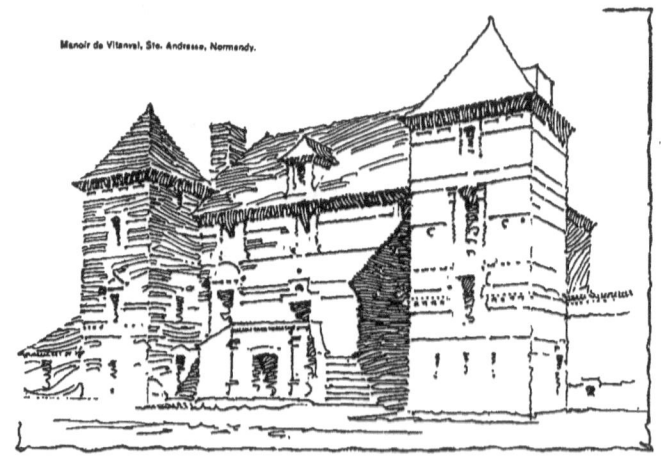

Fig. 13.
A COMPROMISE.

both walls and roof would destroy the white value, and the white value must not be lost. Fig. 13 shows an attempt at a compromise.

Shadows Only. The simplest means for obtaining values is

by the use of shadows. Sometimes the shadows alone will complete a drawing in a very satisfactory manner, as in Fig. 14. Some of the shadows may be made gray, and others black or nearly so, in order to get the needed variety in values.

A building like that shown in Fig. 15, The Alden House, is not favorable to shadows only. It has no porch or other projection sufficiently large to cast a strong shadow. In such a case a little accessory helps one out of the difficulty, and a little rendering of the material gives needed half tone. Otherwise the drawing would be too white.

Fig. 14.
SHADOWS ONLY.

Principality or Accent. We now enter into a matter of composition. One simple rule will be given and there is none more useful. Let there be one place in the drawing where a strong accent of black shall exist. It may be one black, or it may be a group of them. This accent will be found in nearly every illustration in this paper. It is usually best to

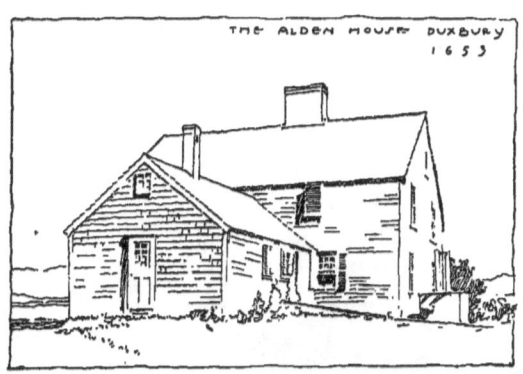

Fig. 15.

get the accent in the building itself, by the aid of some large shadow perhaps, but when there is no chance for this it may be necessary to get it in an accessory such as foliage. This is shown in Fig. 16, a drawing of a barn. In connection with this black accent let there be a large white area if possible. A princi-

MANOIR AT PORT-EN-BESSIN, NORMANDY.

Fig. 17.

pal white, as well as a principal black is thus obtained. Most drawings permit the dark accent and the light area also.

Fig. 17 is rendered to a greater extent than should be attempted by the student in this course, but it may be helpful to call attention to some things in its composition.

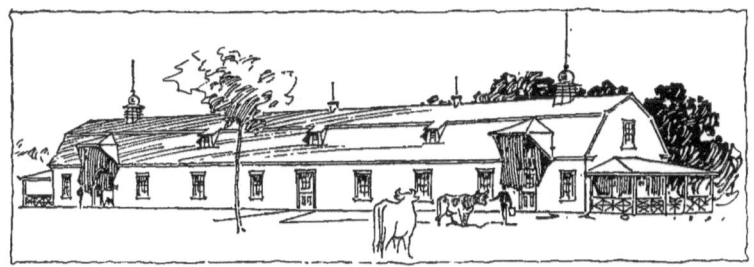

Fig. 16.

The location of the dark accent is apparent in the trees at the left. The other blacks, the trees in front of the building and those down at the extreme right, simply repeat in diminishing force and size, this first dark accent. The light area of the drawing is as distinctly shown as the dark accent; in fact this large light is the feature of this rendering. The light brick rendering of the gable is necessary to confine the light a little more surely to the important portion of the wall. Also, if this light rendering were omitted the building would appear unpleasantly white.

The half tone of the roof is necessary to give a soft contrast to the light wall surface. The sky has its use. Cover it up, and see how the whole subject slumps downward.

Last, but not least, observe that the corners of the drawing are kept free from rendering. This is usually safe. Let the rendering of every sort gather about the central object. The corners of a drawing may then be left to take care of themselves.

PENCIL WORK.

A pencil is a quicker medium for the rendering of a sketch than a pen. A pencil sketch may be made directly on a sheet of drawing paper, and completed on that same sheet. But it is neater to first draw the perspective on smooth white paper, then place Alba tracing paper over this outline, and trace and render. By this means all construction lines in the layout can be omitted,

and the sunny edge of projections can be left out, thus adding greatly to the brightness of the drawing.

Use a soft pencil for rendering, a BB or softer. If the drawing is to be much handled, spray it with fixatif. Trim the sketch, lightly gum the corners, and lay on white card with good margin.

SUMMARY.

The following summary of advice for the rendering of work generally, with pen or pencil may be found helpful.

1. Consider the direction of the light.
2. Discover in the outline before you. the opportunity for a leading dark accent.
3. Look out also for the location of a large light area.
4. Put in shadows.
5. Get at least three distinct values; black, gray and white.
6. Consider the color of roof or the wall, and if necessary use one of them or portions of each for a gray value.
7. Use a very free method.
8. Keep rendering out of the corners of the drawing.

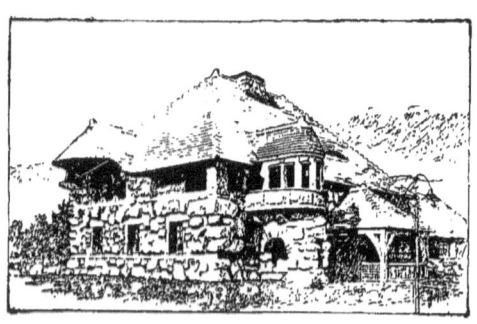

EXAMINATION PLATES.

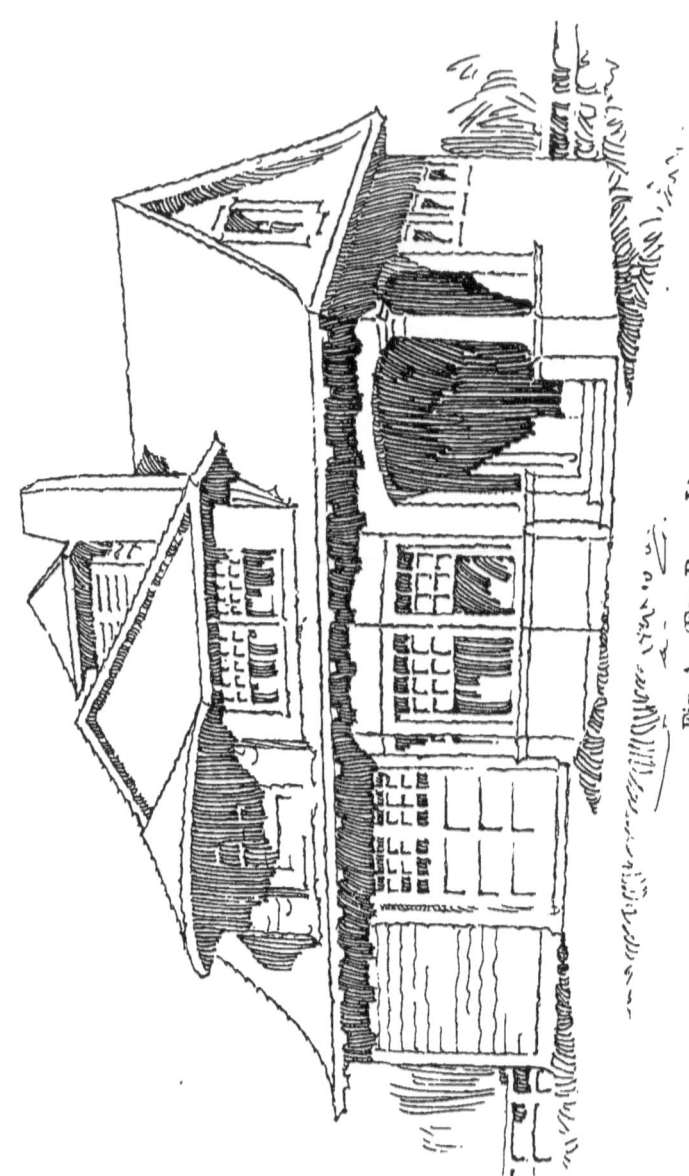

Fig A. (For Plate I.)

FINISHED DRAWING.

EXAMINATION PLATES.

Before attempting to render the drawings in ink, the student is advised to practice both with pencil and ink, using the practice plates provided for the purpose.

PLATE I.

In order to get quickly into the practice, the student will be asked to make a copy of this rendering, Fig. A. Do not try to copy too exactly, but use the same freedom.

Observe that the dark accent is obtained by the large shadow and the end of the long shadow just over it. The dark rendering in the window is brought into the group also.

Having thus formed the accent, it is best that the shadow under the hood in the roof should be made rather light, lest it come into competition with the porch shadow. If the student prefers he may make it a trifle darker than here shown.

A little clapboard rendering is put in on the left, to make still more evident the large light, which occurs mainly on the roof but at the same time takes in other white spaces at that end of the drawing.

PLATE II.

This subject introduces a roof rendering, also a simple treatment of windows and blinds. Here the roof serves as a half-tone value. The shadow of the eaves and some of the blinds are the black values. To get the dark accent, the nearest blinds and the near portion of the shadow on the eaves are made very dark.

The shadow under the porch shows how safely much of the detail of the door itself may be omitted and not be missed. A broad treatment is better than a fussy one. Observe that the roof lines are made as free as possible, avoiding a straight, wiry line.

After copying this plate original work may be attempted.

PLATES III AND IV.

Make the shadows only for the first rendering, Plate III, just as shown in this value scheme, Fig. C. Then make a second drawing of the same, Plate IV, and give a half tone to the front area of the roof, and to the end of the roof a darker value, as shown in suggestion in upper corner. Finally on this second

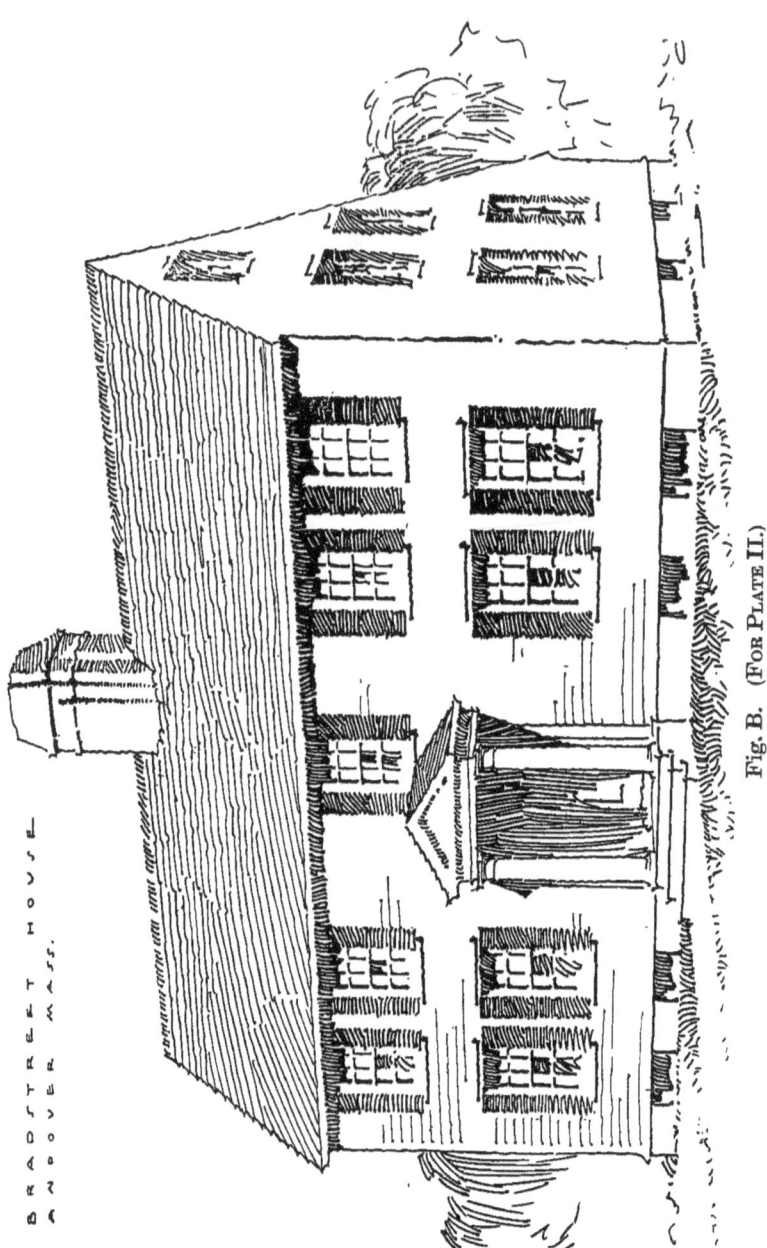

Fig. B. (For Plate II.)

Bradstreet House, Andover Mass.

drawing, put a small amount of rendering on the wall at the distant right, in the same manner as on Plate II. This will give a large white light on the walls nearest the observer. The long shadows under the eaves should be darkest at the corner nearest the observer and gradually lighten up as it approaches either end.

Fig. C. (For Plates III and IV.)

PLATE V.

Put in the shadows first. Get the nearest shadows very dark; then give a half-tone rendering to the whole of the brick-wall surface. Do not ink in the lines at the edges of the brick walls. Let

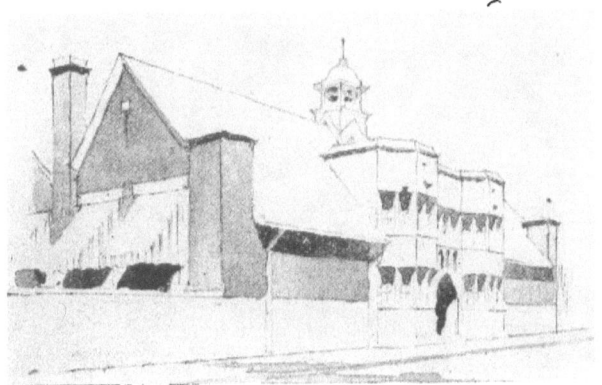

Fig. D. (For Plate V.)

your rendering make the edge as shown in Fig. 18. An outline in such a place produces a mechanical looking rendering, as is seen in the illustration. Outlining is absolutely necessary where there

is no rendering, but in connection with it, omit the outline, if possible.

PLATE VI.

The doorway shadow selects for itself the honor of being the leading accent; the shadows at left and right simply repeat it in a small way. The roof affords an opportunity for half-tone. The

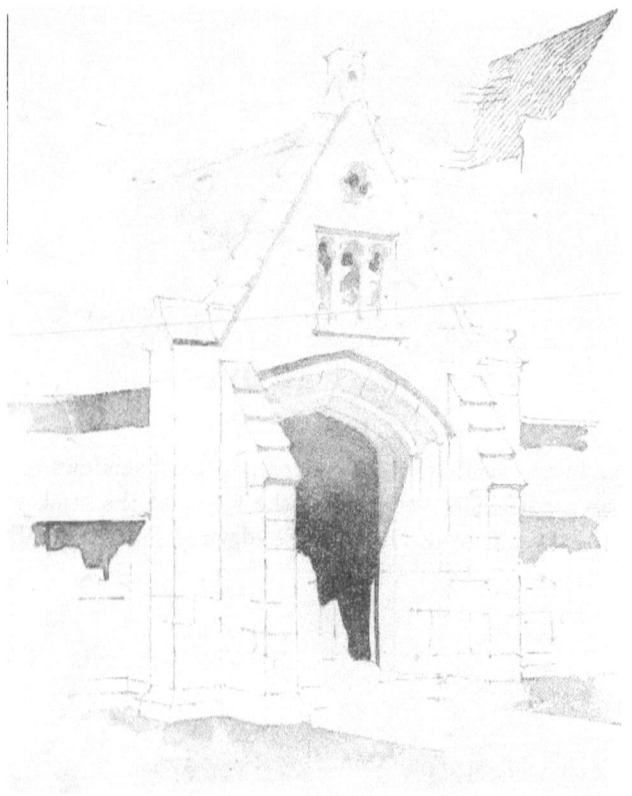

Fig. E. (FOR PLATE VI.)

grass, which may be rendered as illustrated in the two preceding examples, gives also an additional half-tone value. To retain or produce a large light area, the stone jointing should be omitted on the upper portion of the wall, as indicated in the scheme. The roof may be rendered in a free line method, as shown in the sketch. With a good quality of line, and a free, vigorous method, this drawing will be a brilliant one, as its composition of values is favorable.

This ends the practice. Only a beginning has been made in the work—a foundation laid, but it is a safe one. What has been

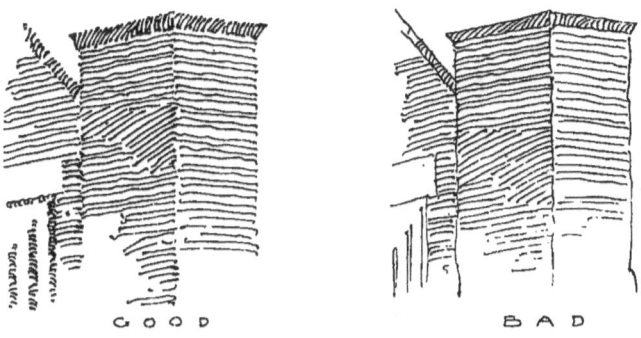

Fig. 18.

taught will be a help to a further pursuit of the subject should the student feel that he has developed sufficient talent to encourage further study.

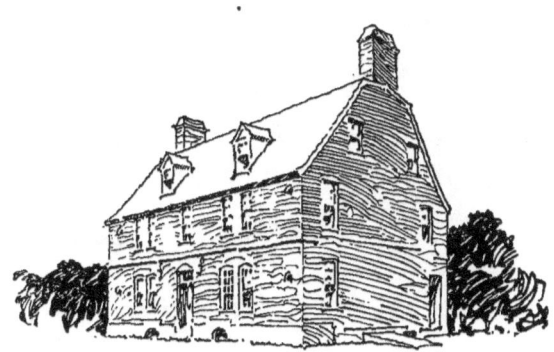

Suggestion for treatment of house showing roof in light with half-tone value to walls.

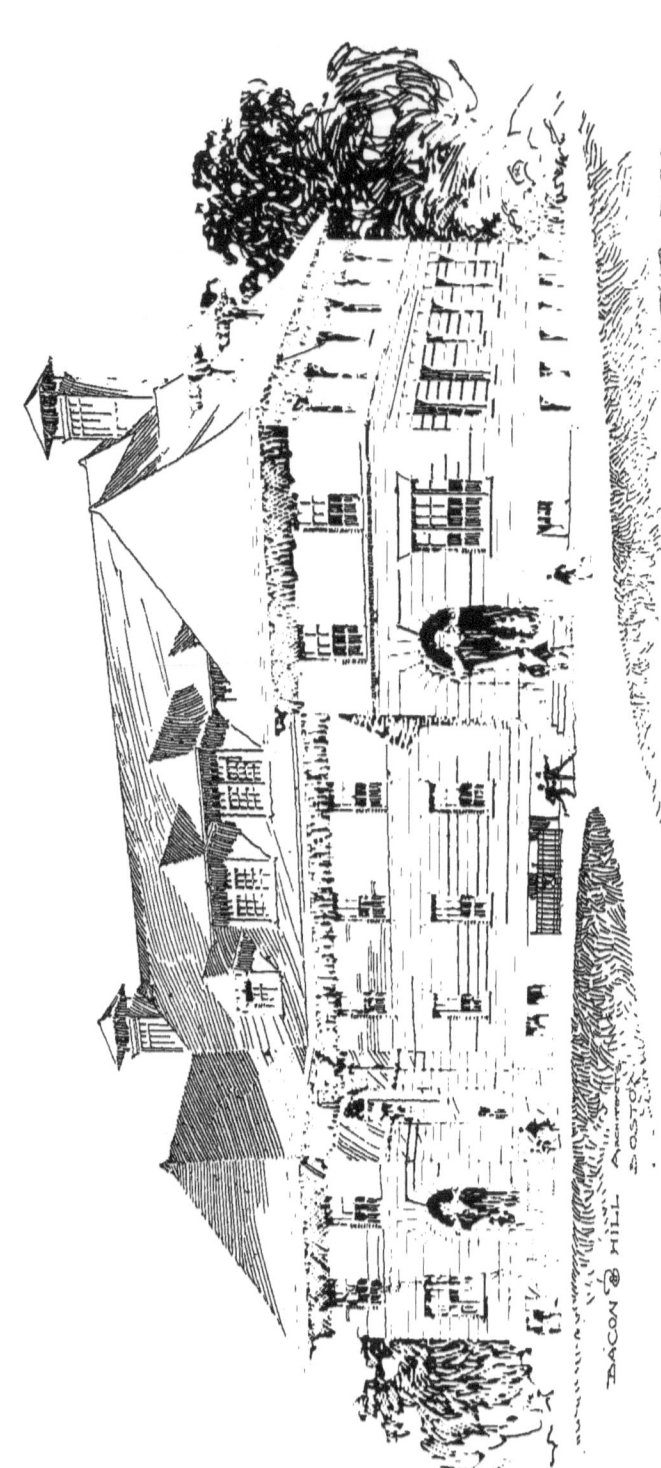

Fig. F. (For Plate VII.)

DELBURY CHURCH,
SHROPSHIRE, ENG.

Fig. G. (For Plate VIII.)

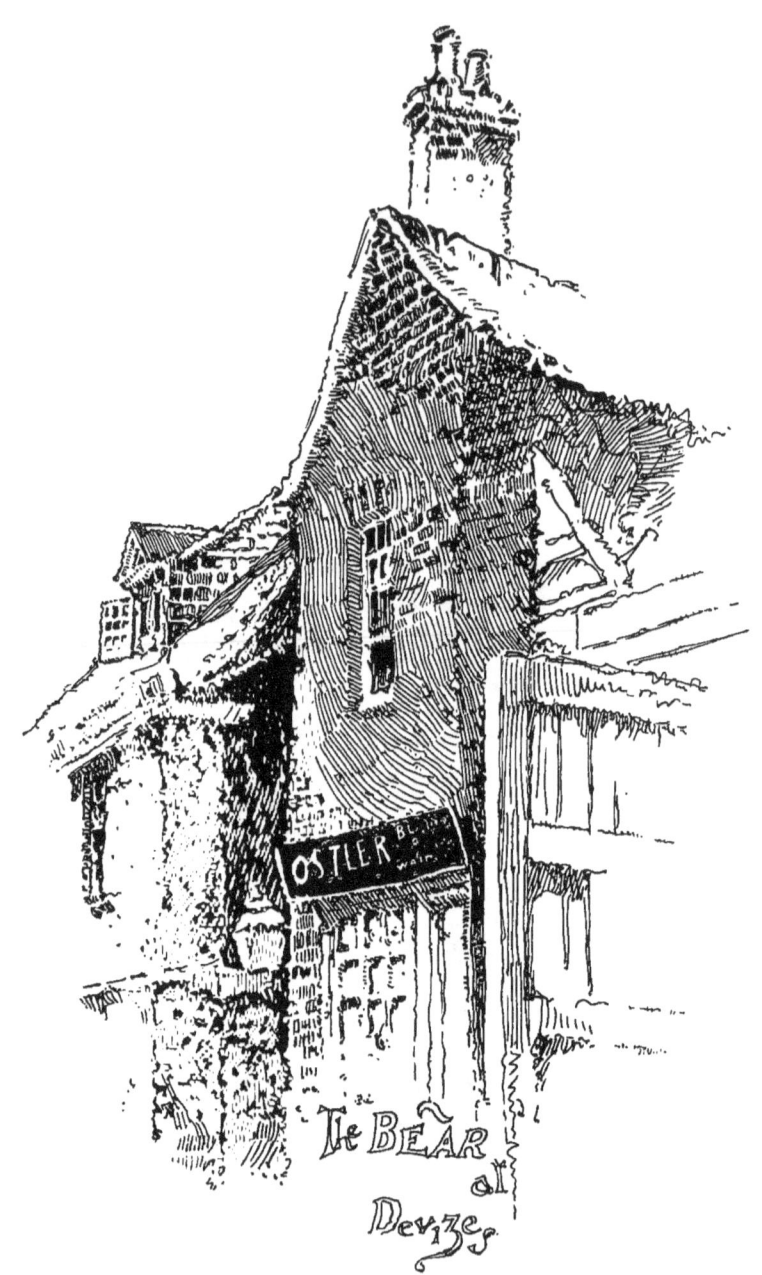

Fig. II. (For Plate IX.)

Copy of a drawing by Herbert Railton, an illustration in the English Illustrated Magazine in an article entitled "Coaching Days and Coaching Ways," Macmillan & Co., Publishers, by permission. This copy made by J. A. Kane, Pen and Ink Class, Massachusetts Institute of Technology, D. A. Gregg, Teacher.

RENDERING

OPTIONAL PLATES

For further help to the student the excellent examples of rendering shown in Figs. F, G, and H are furnished. These are not required in the examination, but the accompanying outlines may be carefully rendered and sent to the School for criticism.

PLATE VII*

The finished drawing for this plate is shown in Fig. F. As to its composition, a scheme is here used that is very frequently possible and advisable, i. e., the making of a large light effect on the near portion of the building—not a small one, but one of good area. The color value of the brick wall and of the roof is ignored in order to get this large light. It is obtained by simply rendering thoughtfully around it.

Another item in the composition is the leading dark value, in the tree, repeated in less intensity in the doorways, windows, shadows, etc. Note also that the work is rounded up agreeably, just enough to balance the values.

As to technique, strive for freedom in direction and to avoid a hard liney result. Wherever possible the sunny edges are not drawn in by a line, the rendering itself producing sufficient definition. Again, note the distinct values, black, gray and white.

PLATE VIII* -

The finished drawing for this plate is shown in Fig. G. As ever recommended, a free flowing line and method are used in every part of the drawing. On sunny edges (see buttresses) the line is omitted entirely. As to difference in values, the black, gray and white are distinctly marked.

In composition, the large black of the tree is the leading accent, and its black is repeated in small areas in various parts of the work. The subject affords as well a large leading light on the side of the tower, repeated also. Again (and this is very important), the corners of the drawing are left untouched, which gives a quiet grouping of all the values.

*Optional

PLATE IX*

The finished drawing for this plate is shown in Fig. H. Probably no draughtsman living can surpass Robert Railton in brilliant technique, the free use of line, and ingenious method. His work is especially adapted to architectural illustration.

It will repay good effort to copy this with care. This copy retains most commendably the spirit of the original. Observe the absence of purely straight lines, and the great freedom used in all outlines.

*Optional

EXAMINATION PLATES.

With this Instruction Paper are sent three sets of outline plates; one set for practice with pencil, one set for practice with ink and the third set (on better paper) to be rendered in ink and sent to the School for correction and criticism. The practice work need not be sent to the School.

Should the ink not flow well, rub the whole plate lightly with a soft eraser, or rub over it a little powdered chalk. Before beginning to render the drawing, dust off any loose chalk remaining on the paper.

Plates I to VI inclusive constitute the examination for this instruction paper. The student's name should be lettered in the lower right-hand corner in a manner similar to that shown in the illustrations of the Instruction Paper.

Plates VII, VIII and IX are not required but may be rendered and sent to the School for criticism if desired.

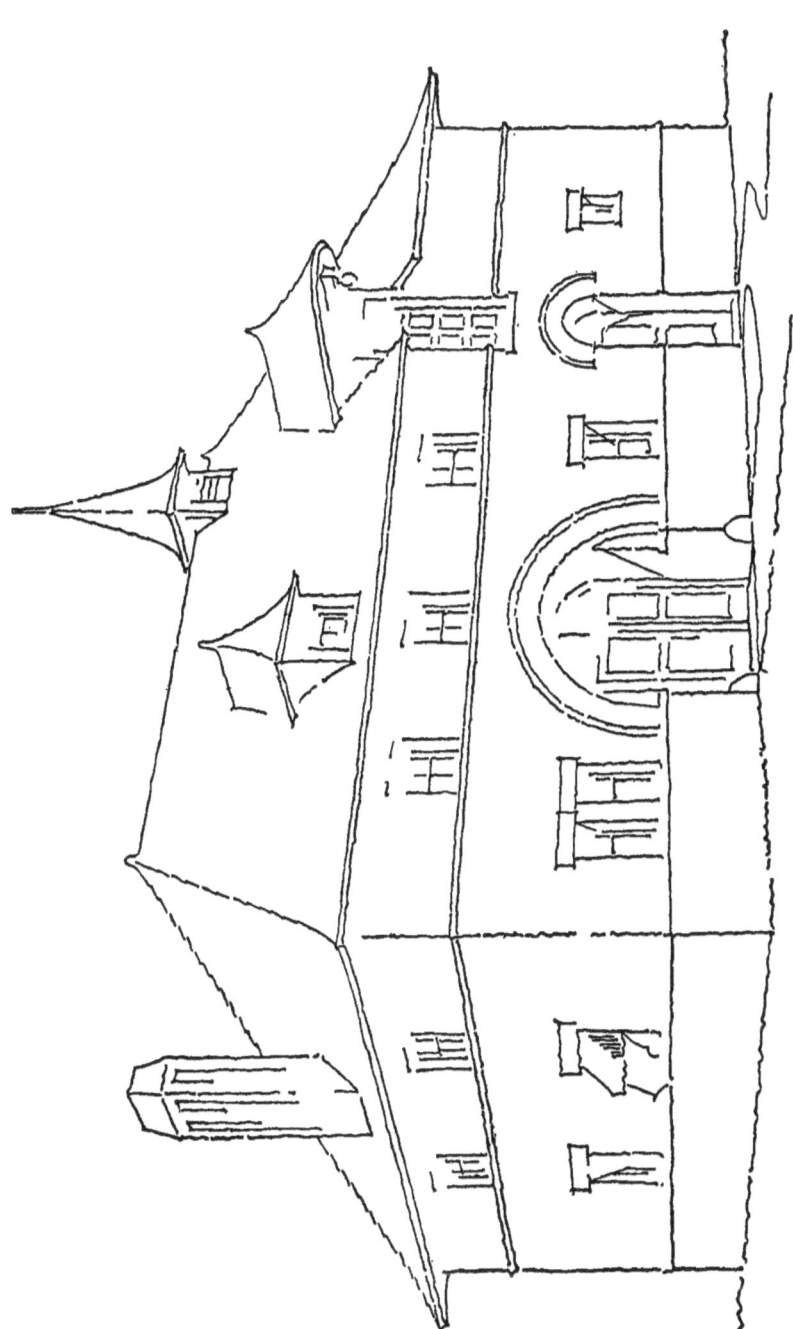

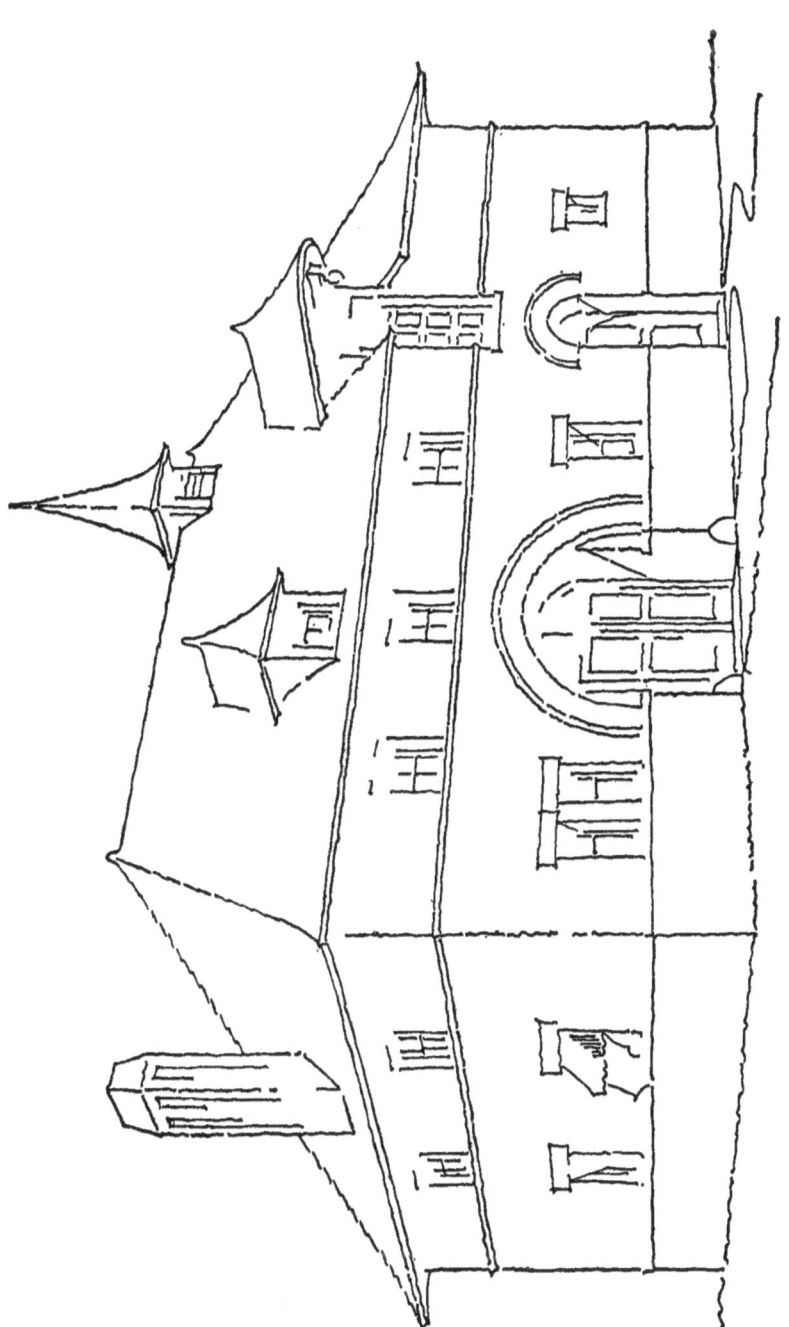

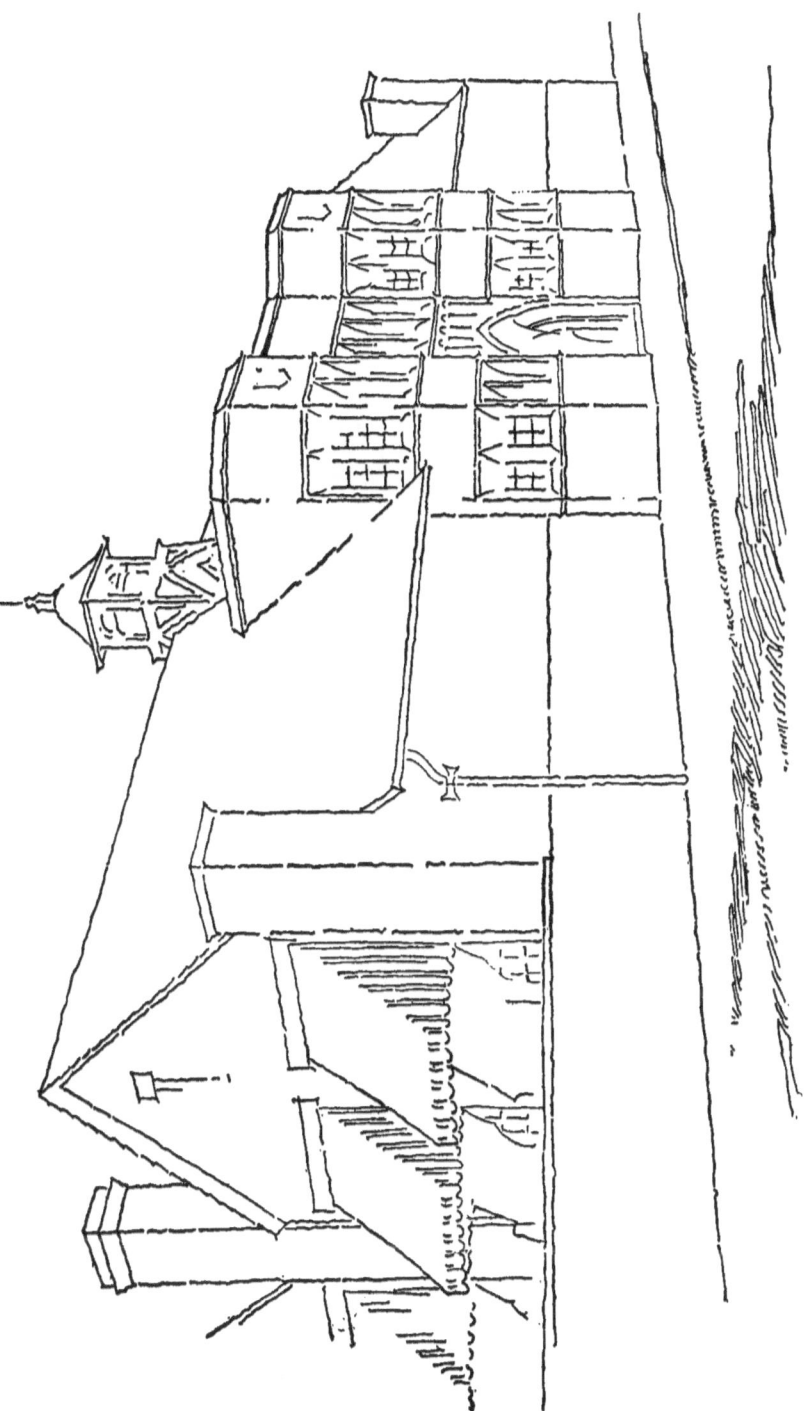

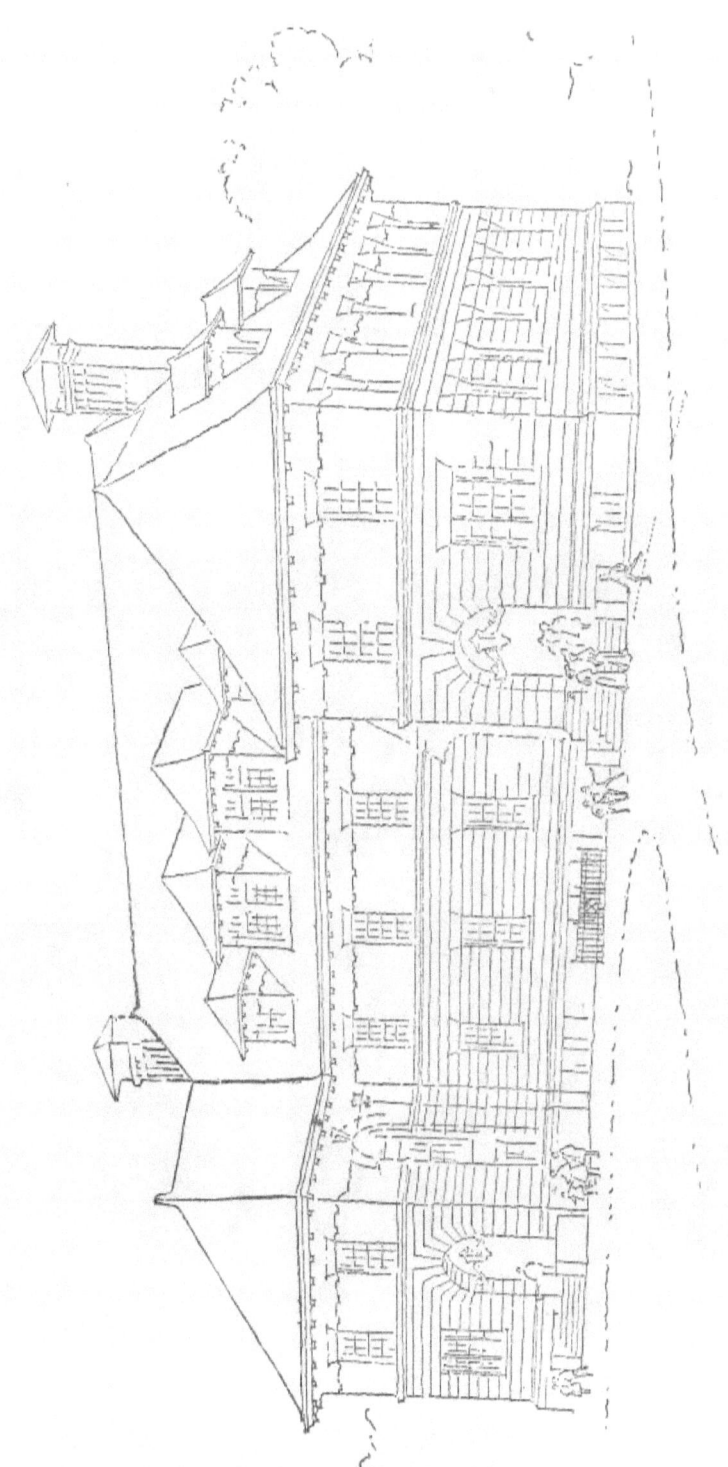

Plate 9.

www.ingramcontent.com/pod-product-compliance
Lightning Source LLC
Chambersburg PA
CBHW020712180526
45163CB00008B/3054